Patterns of Consciousness:

Part II:

Transcendent Emergence

By A.P. Garfoot

Patterns of Consciousness:

Part II:

Transcendent Emergence

ISBN: 978-1-291-34636-7

(c) Alan Peter Garfoot 2013

Lulu Press

London

Contents:

Epiphany of Fate	1
Truid Dynamics	2
Psyber Suit	3
Mystic Quill	4
Spyke	5
Cyber-Psy	6
O' Connor	7
Broken Morning	8
Magistar Mindware	9
Subtle Bosons	10
An Elegant Precision	11
Supersoldier	12
Telekinetic Shielding	13
Rebirth of Metaphysics	14
Leonine	15
A Spellcasters Grace	16
Toucan Chameleon	17
The Atlantian Pleiadian	18
Joyous Expectancies	19
Shadowmorph Beauty	20
Psych-O	21
Between Focus	22
First Love	23
Sensei	24
Agent Cuckoo	25
Blood In The Streets	26
Ascended Soul	27
Encouraging Words	28
Warlock	29
Hyperspatial Acid Ninja	30
Ministry of Deviants	31
Wormhole Warp-Field	32
Tolar tech	33
Spiral Dance	34

Shield of Infinity 35
Global Aftermath 36

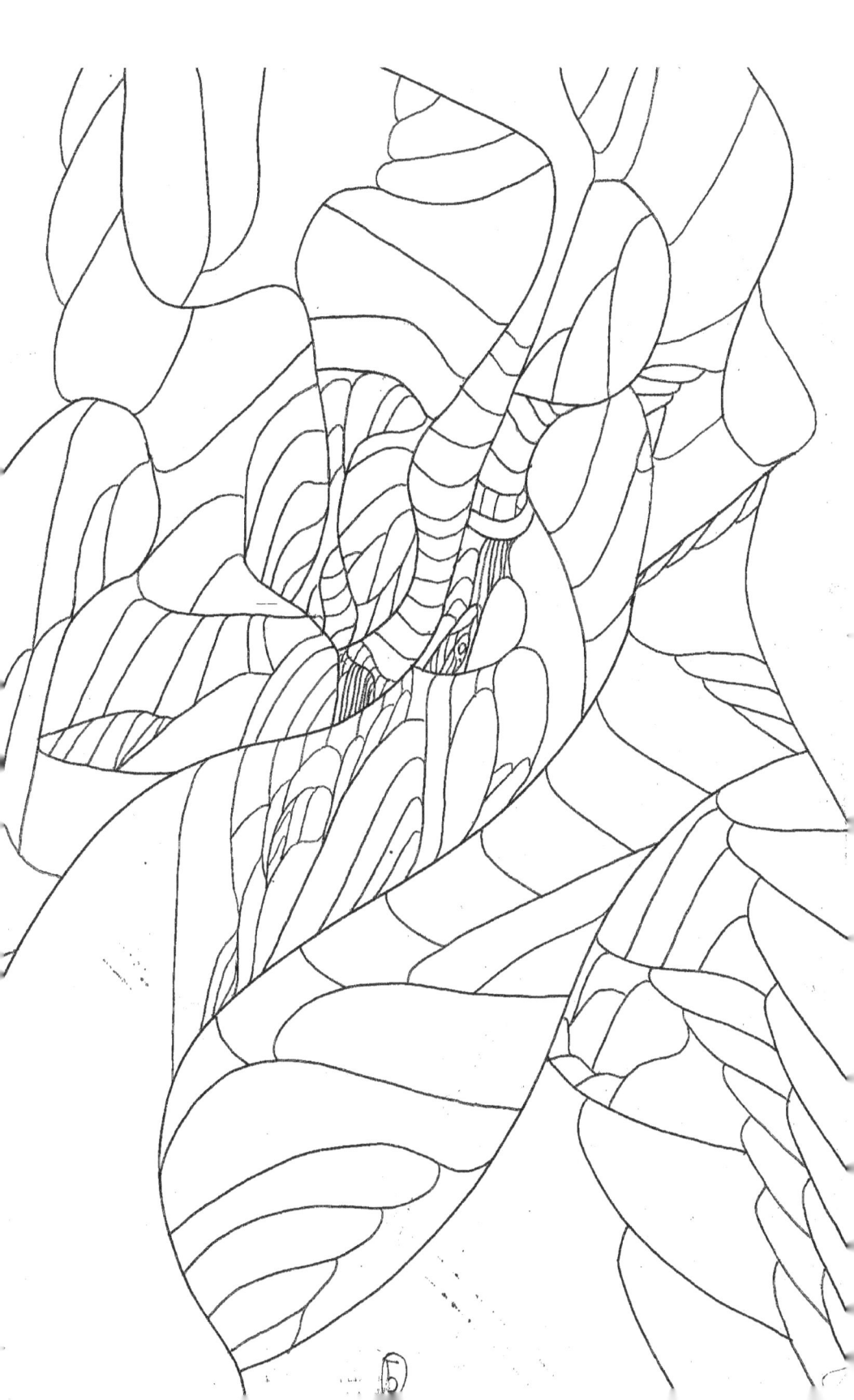

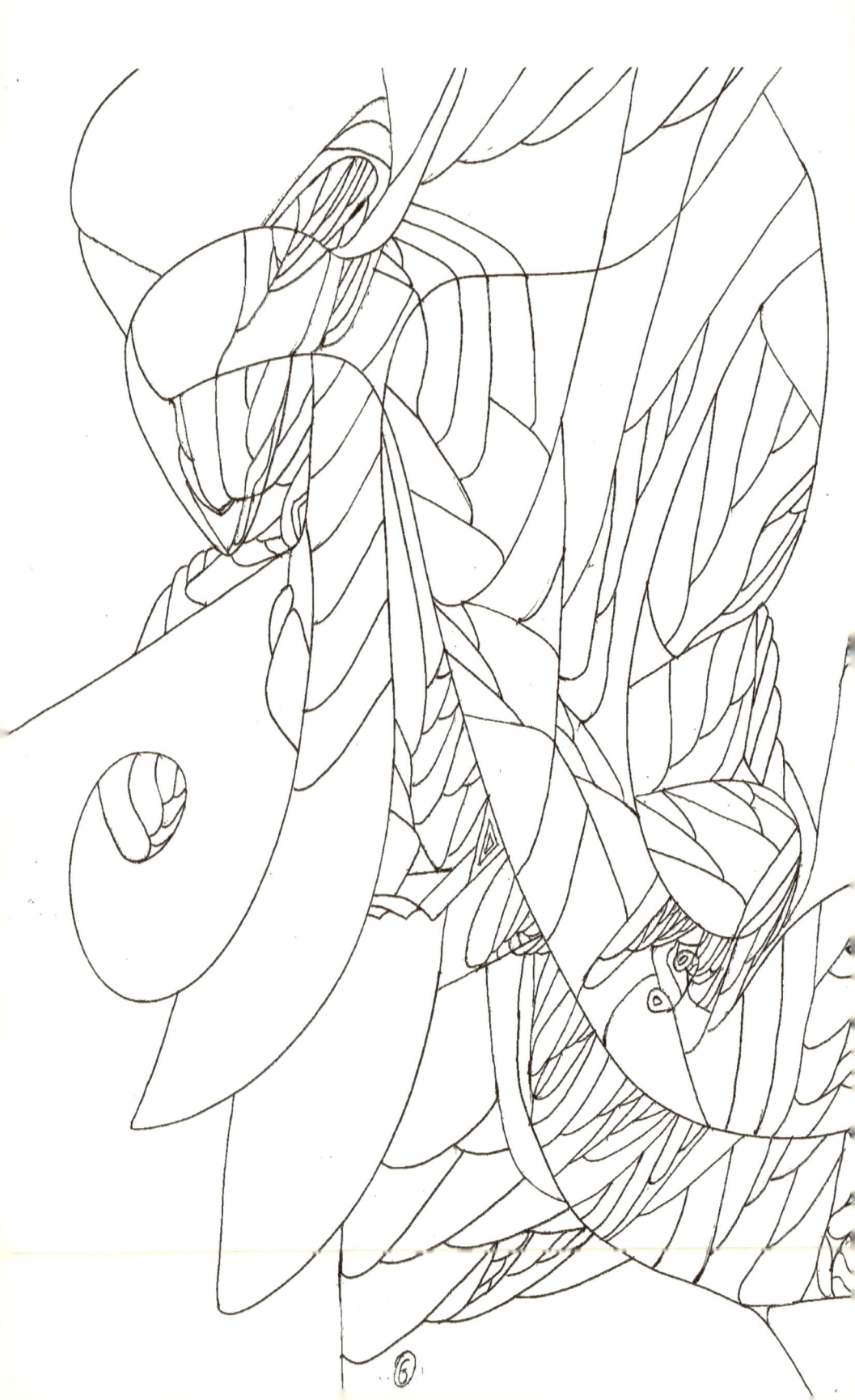

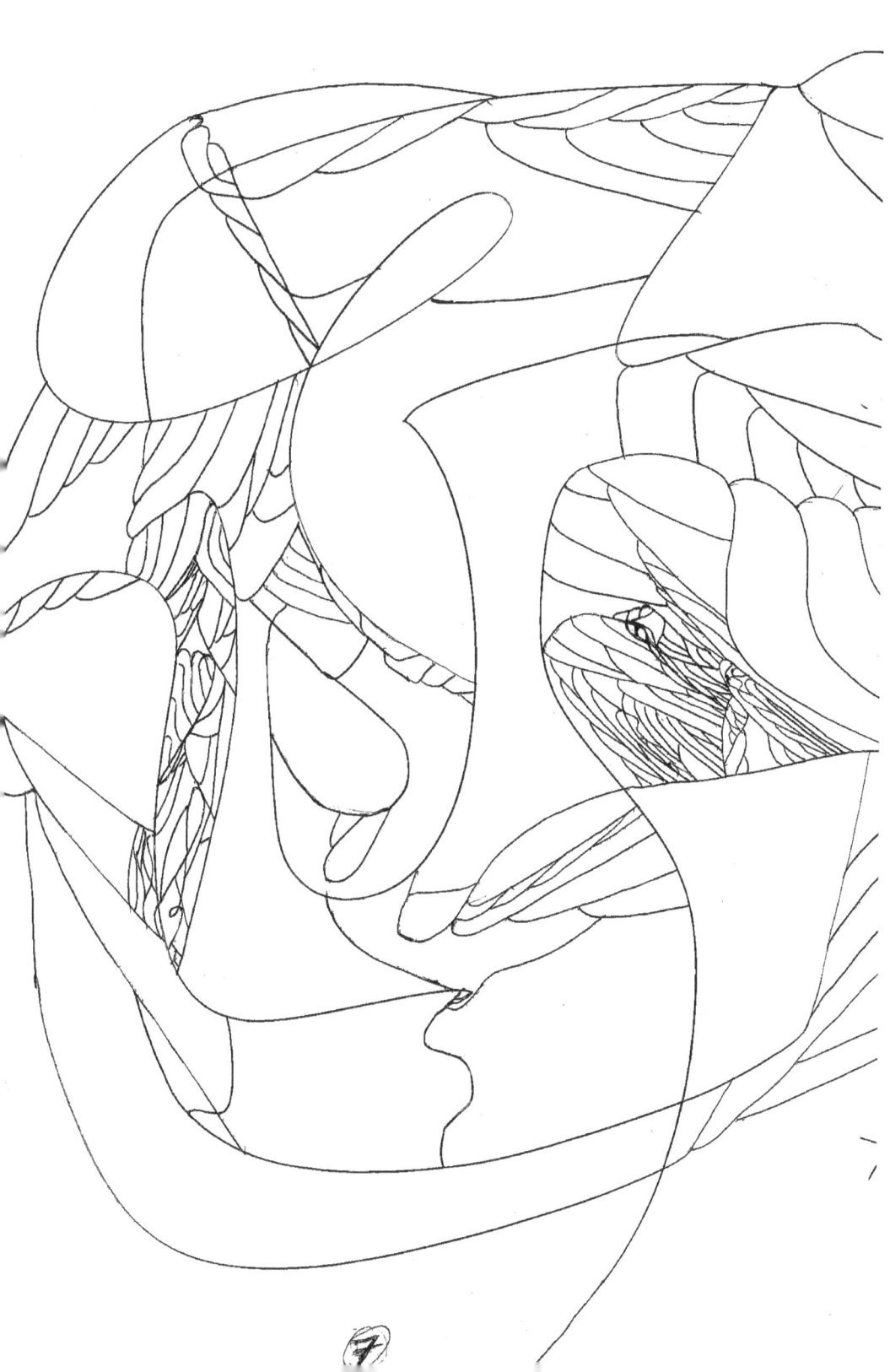

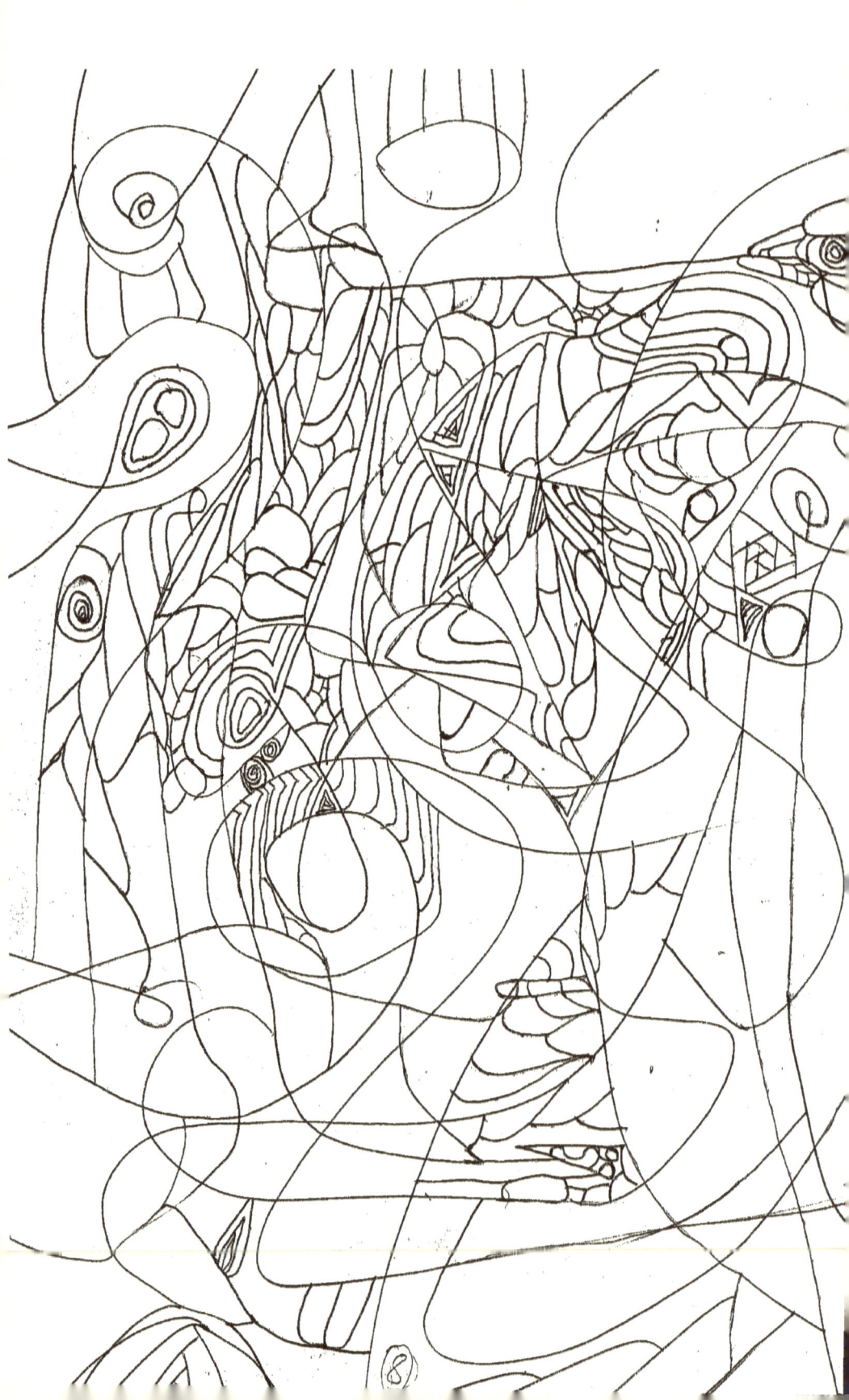

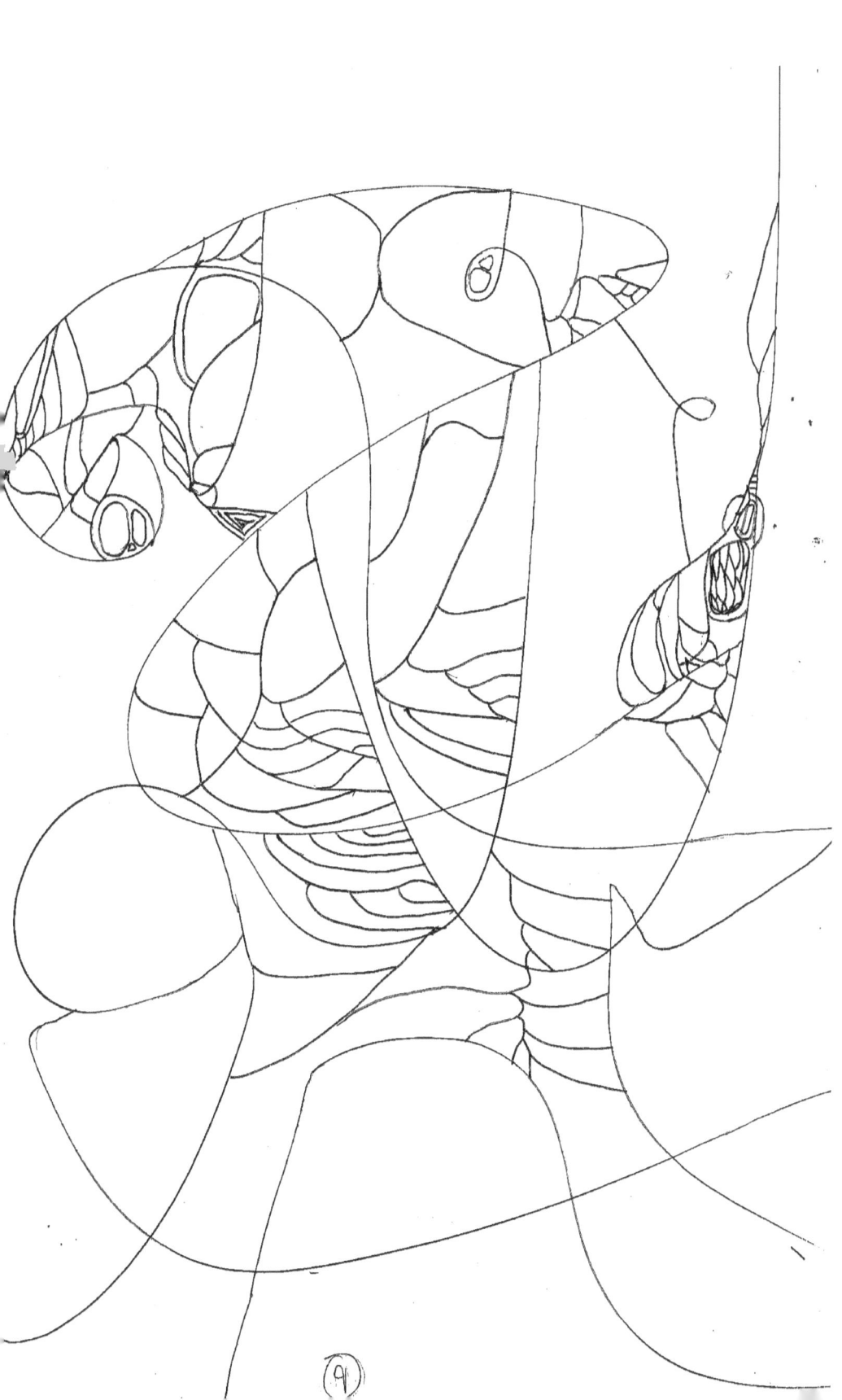

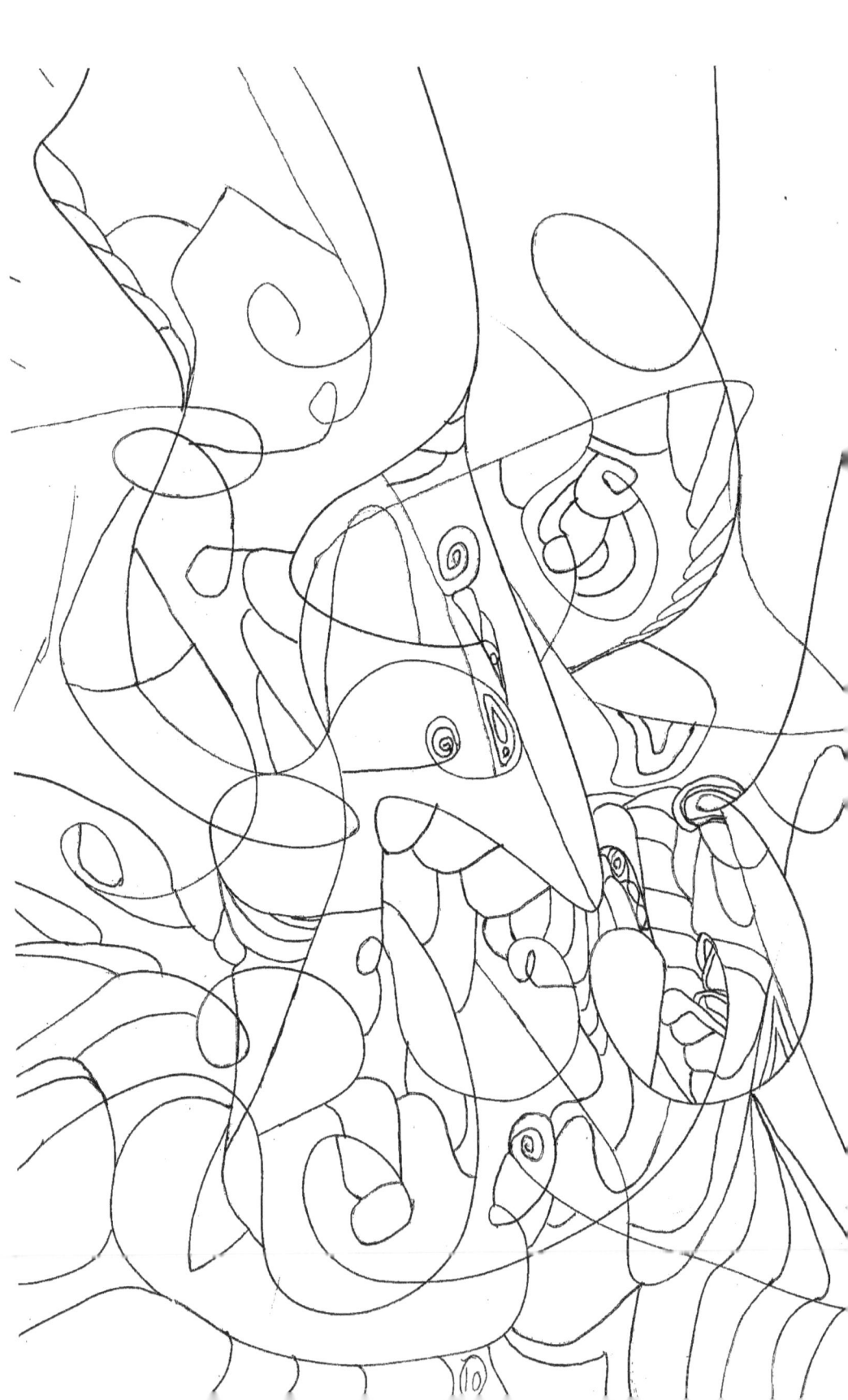

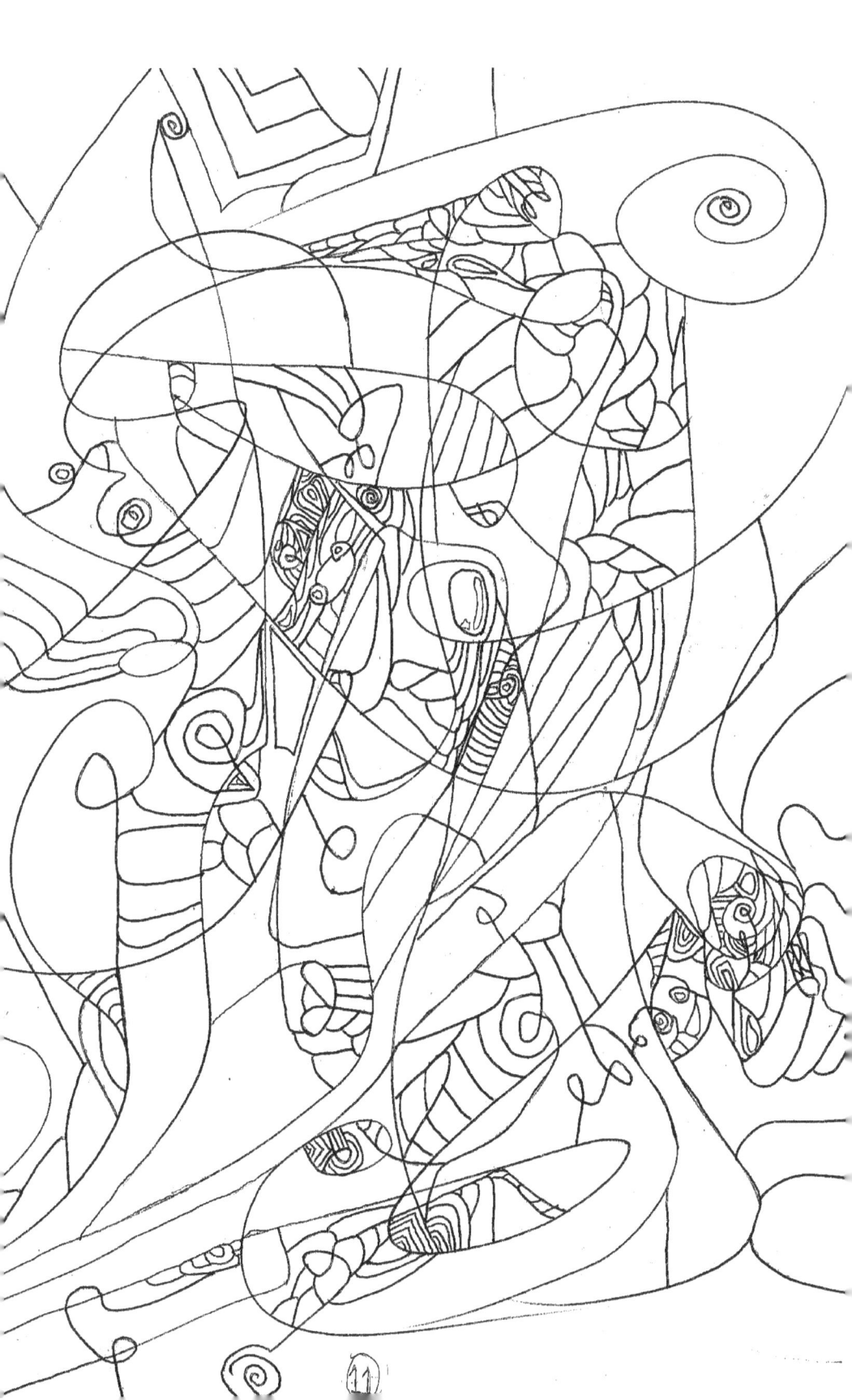

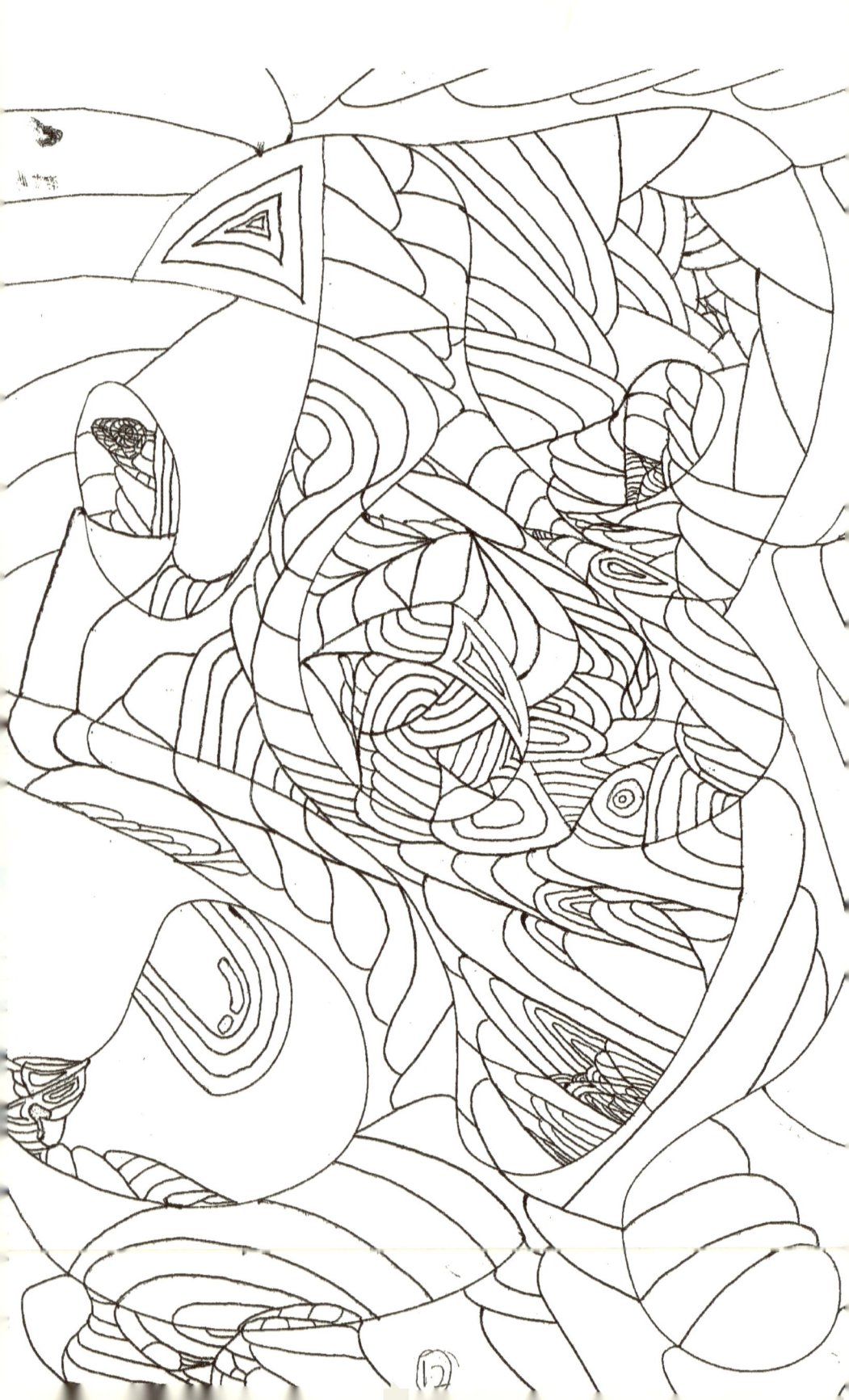

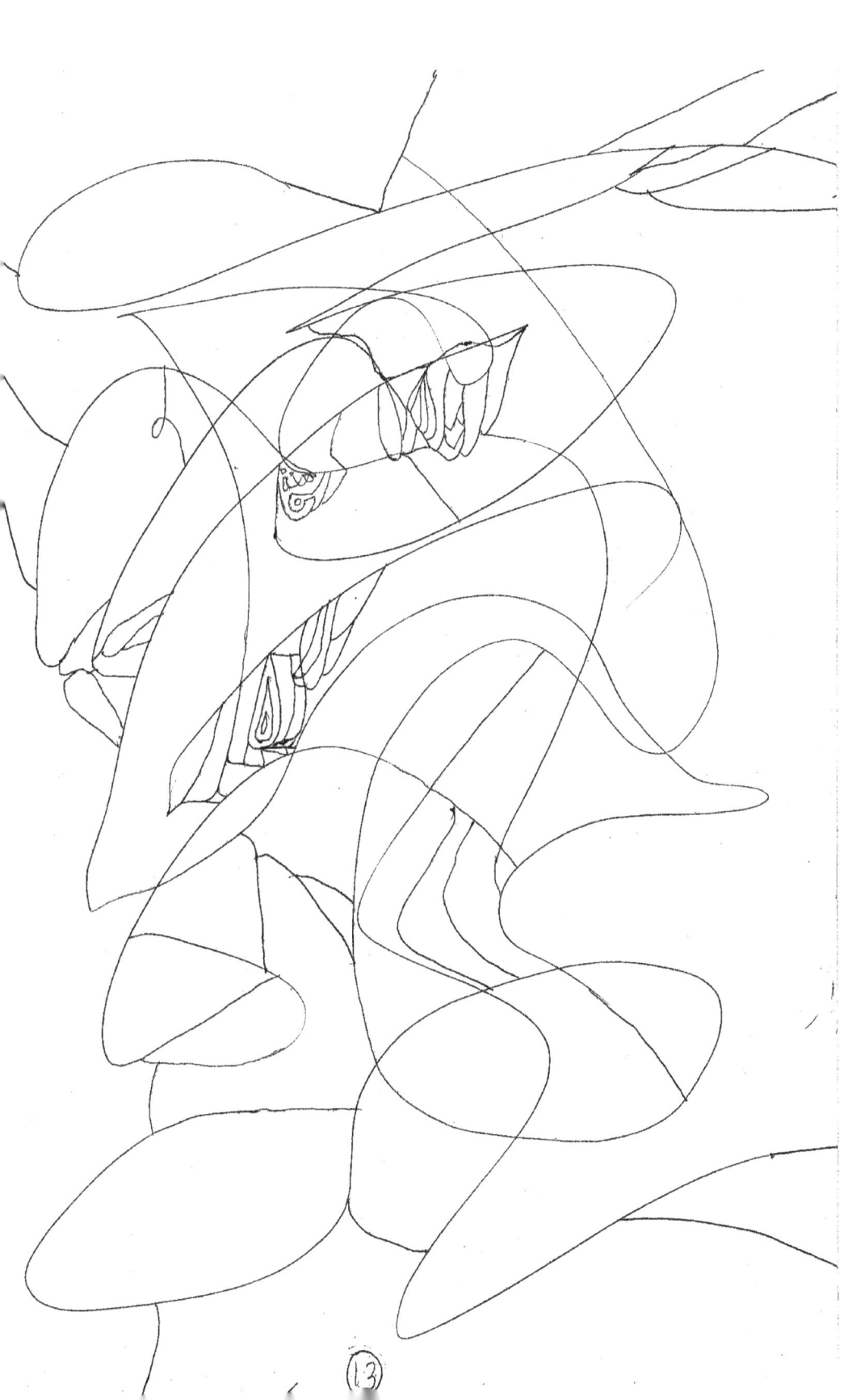

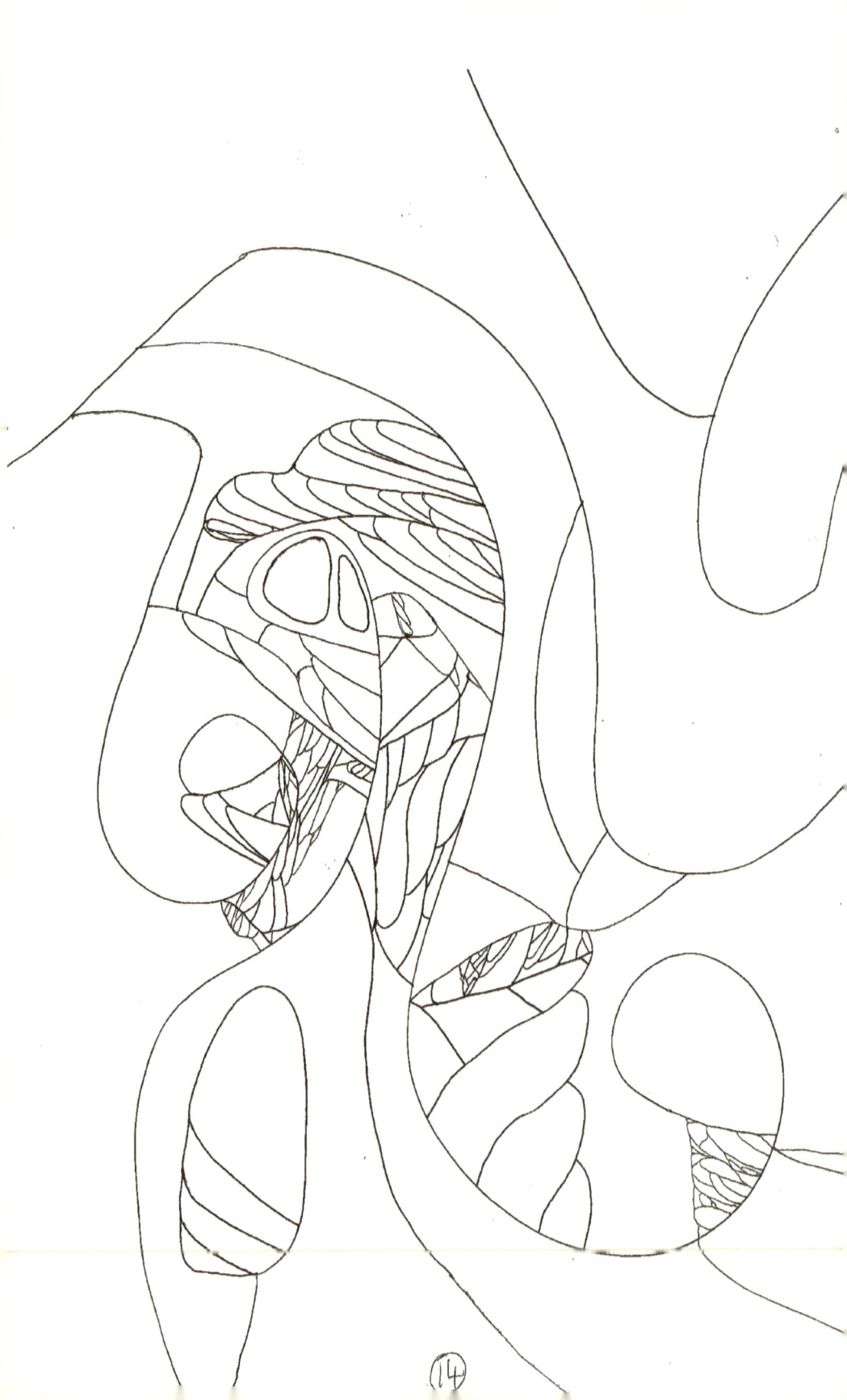

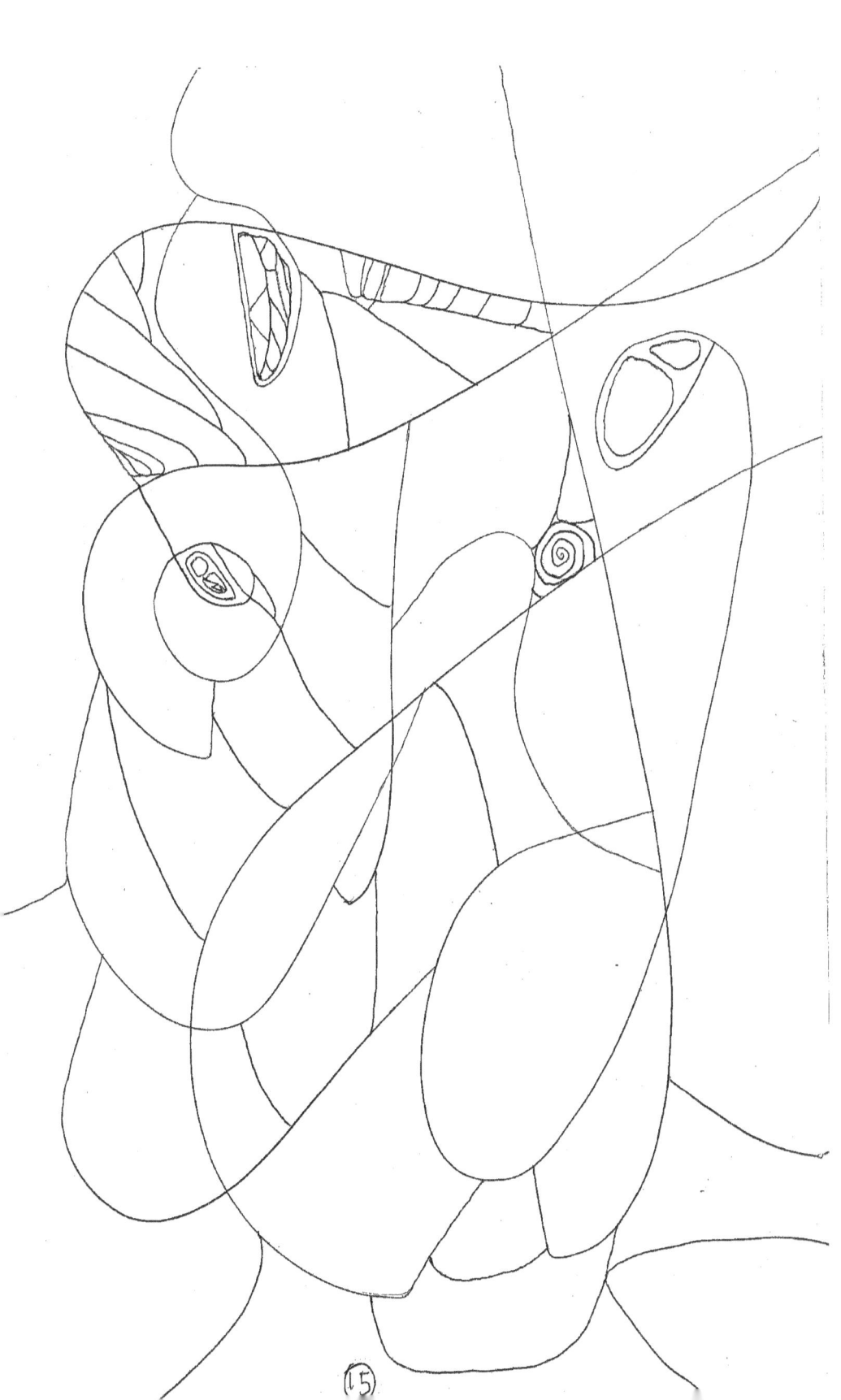

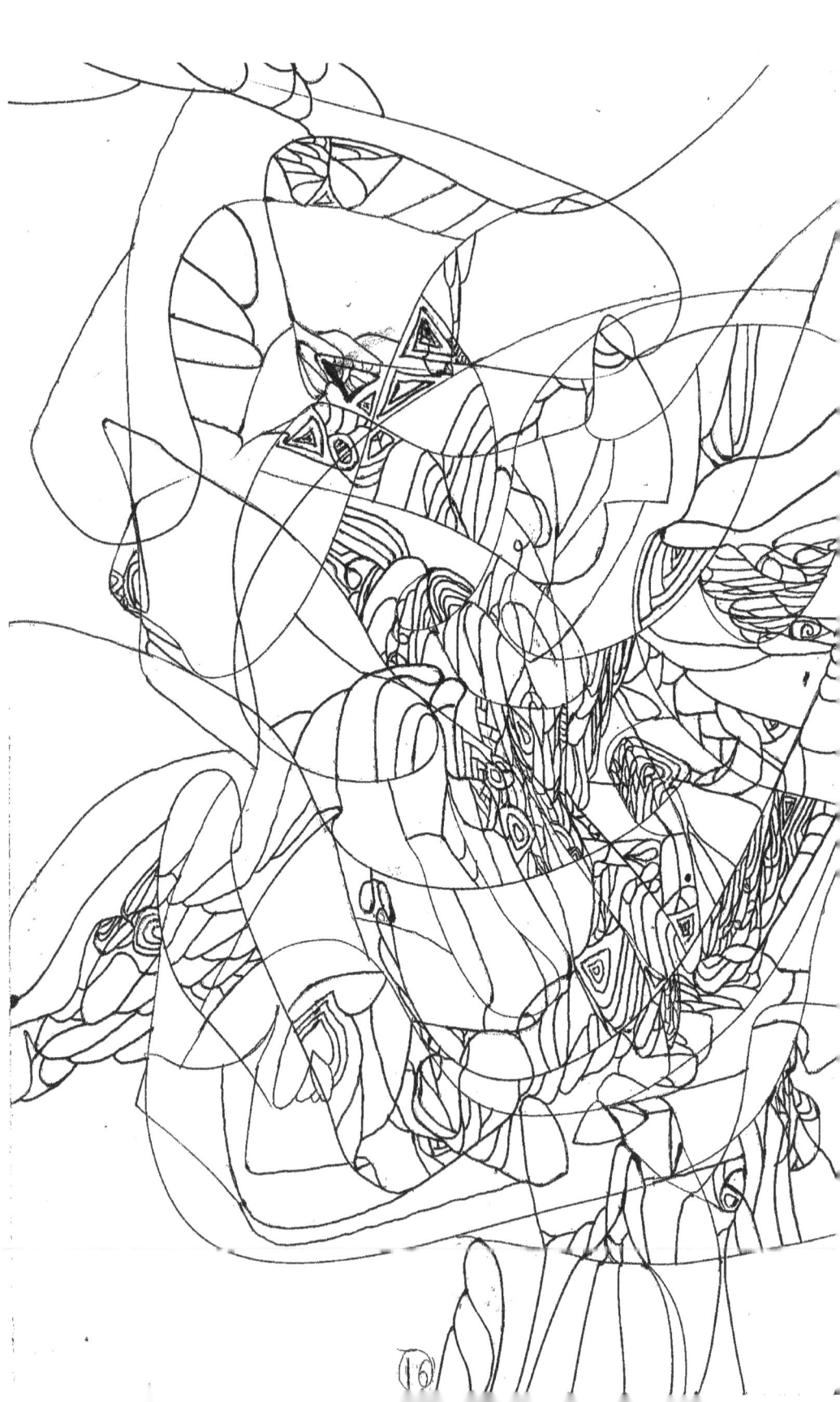

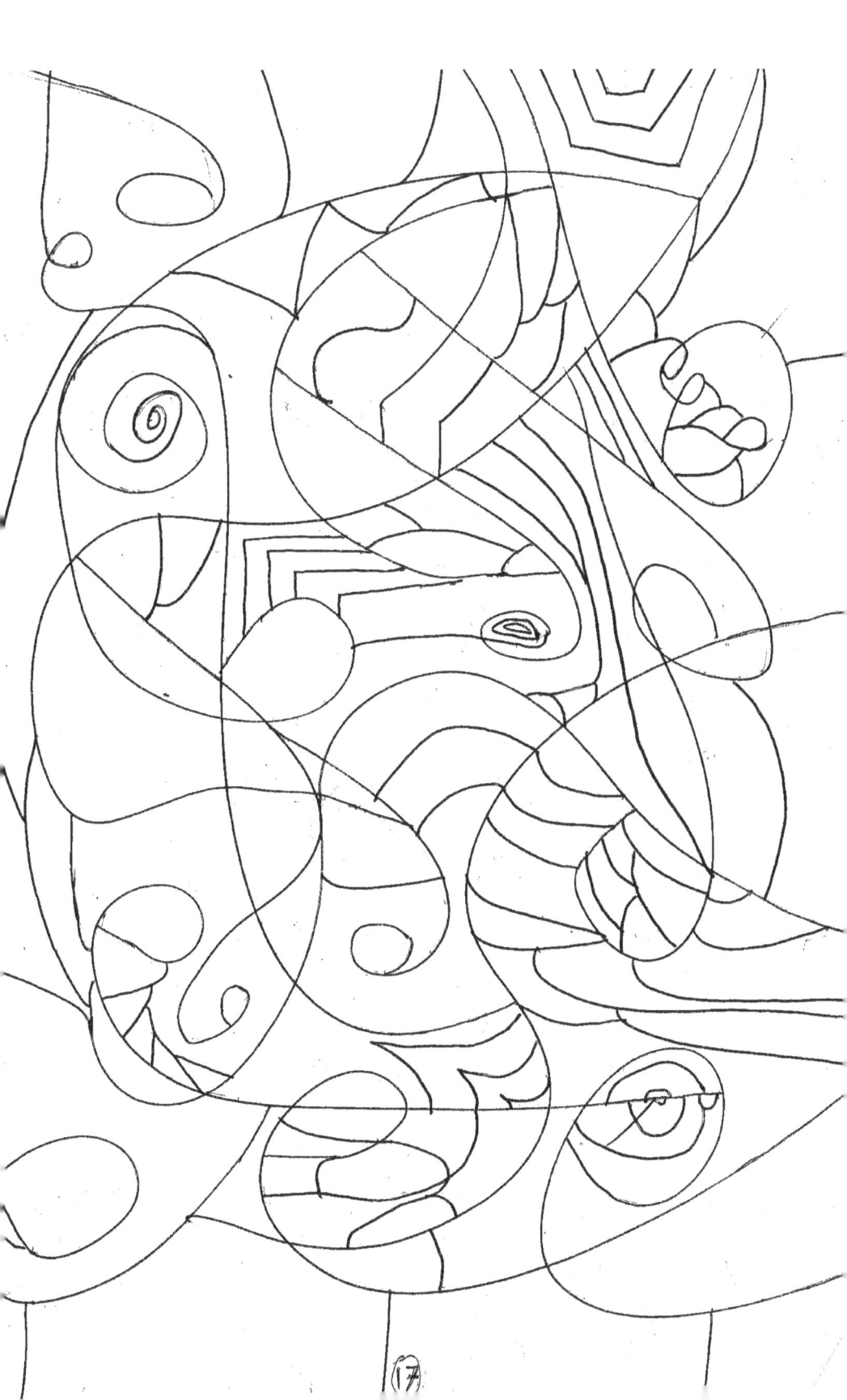

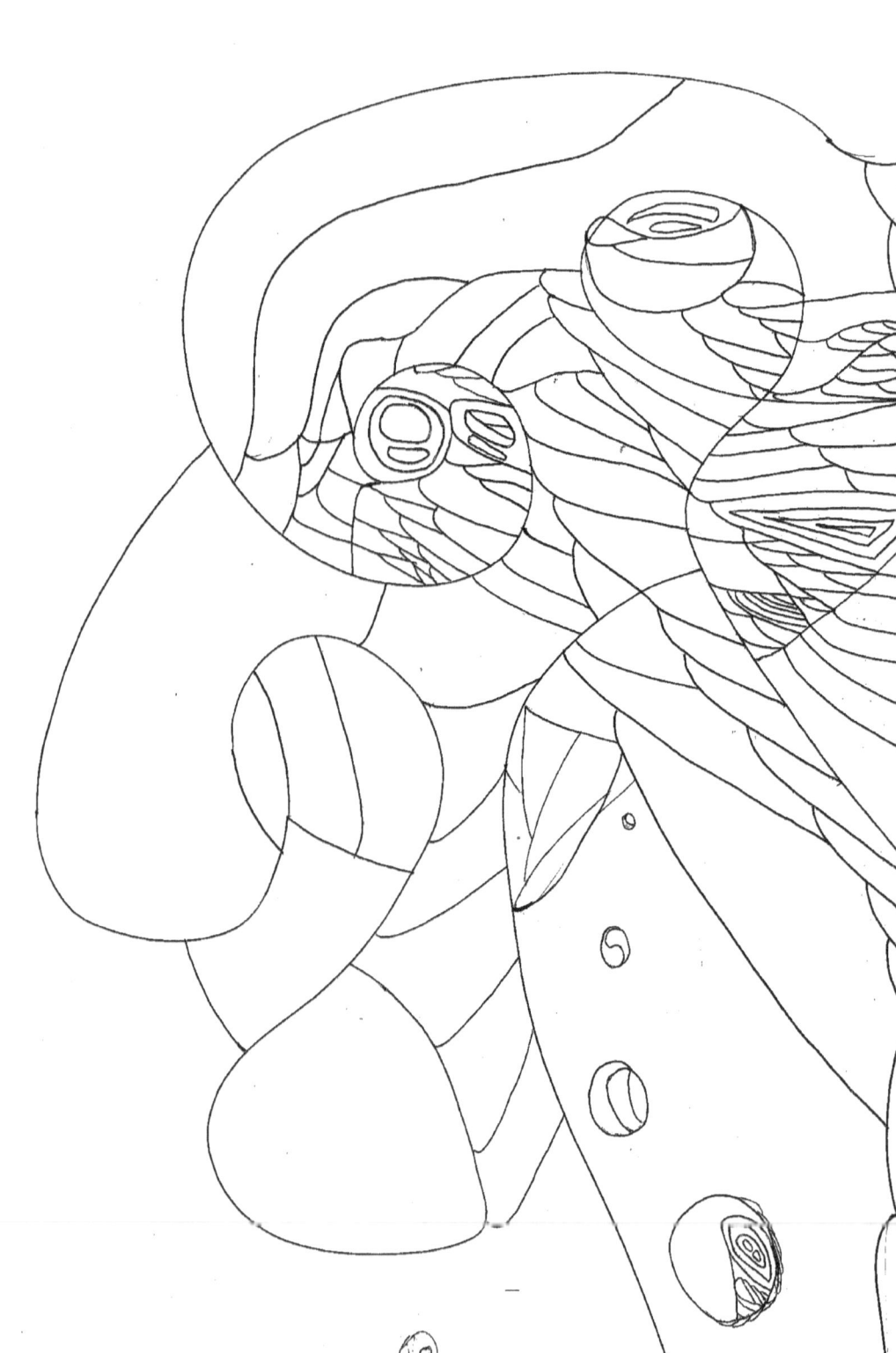

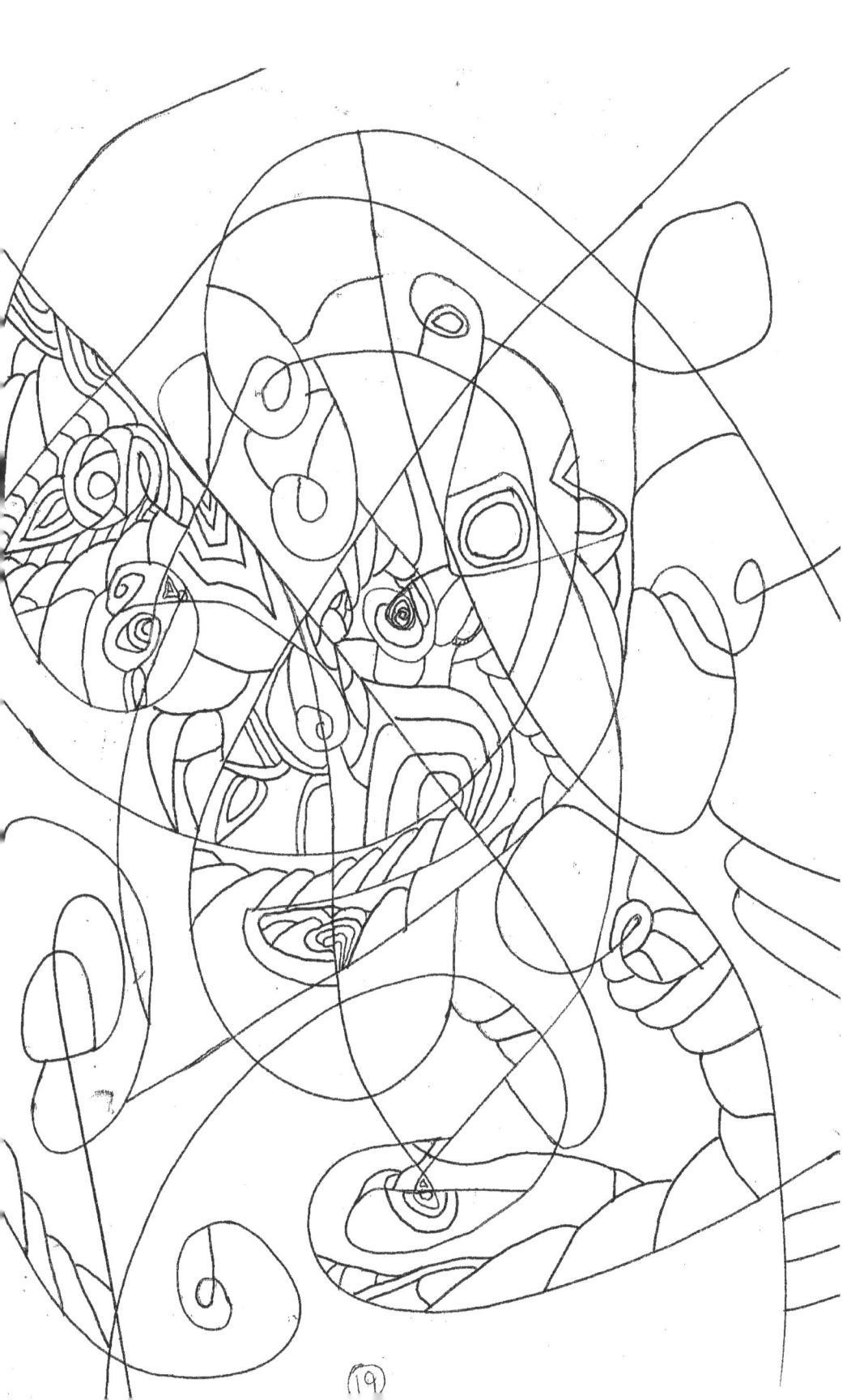

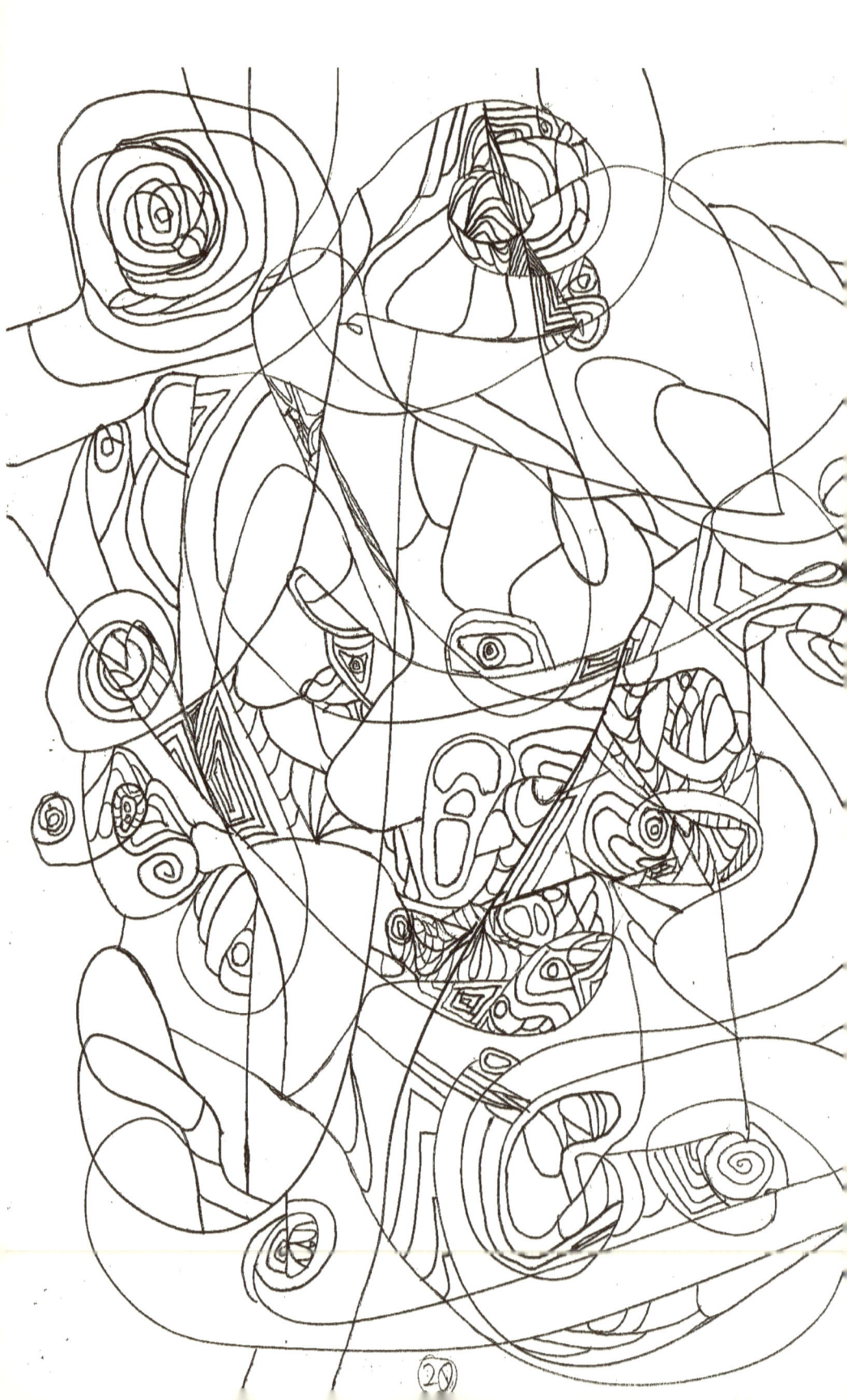

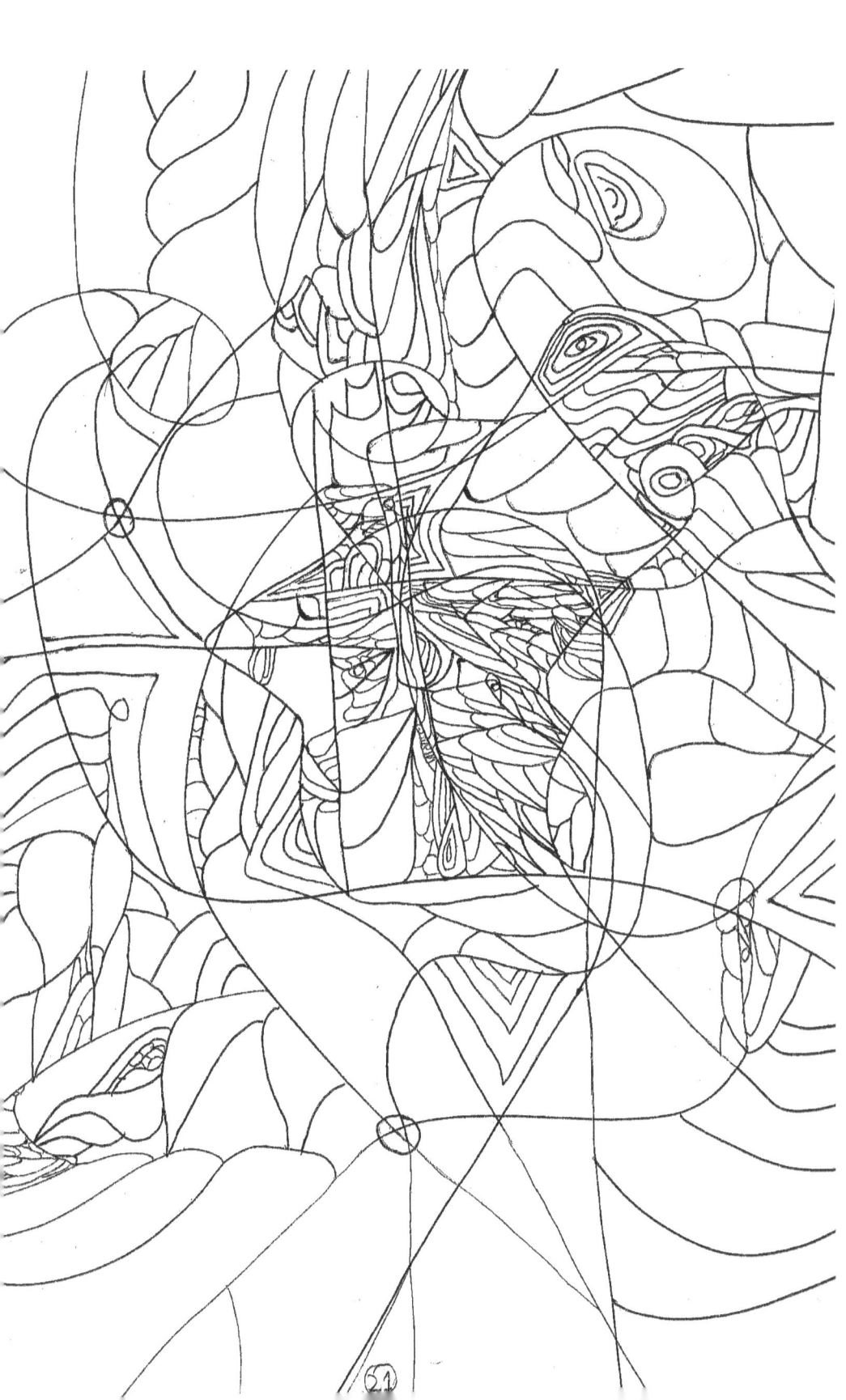

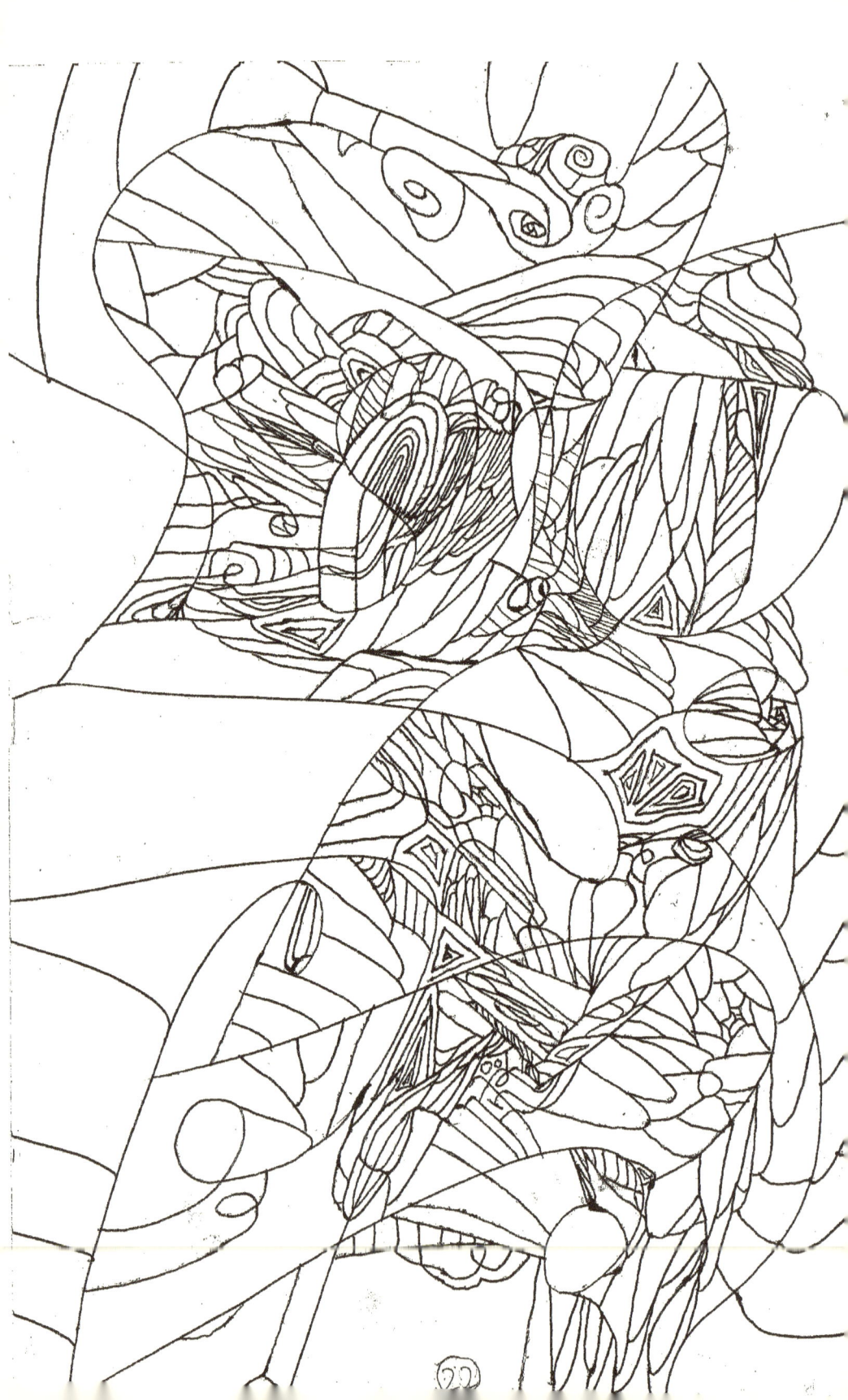

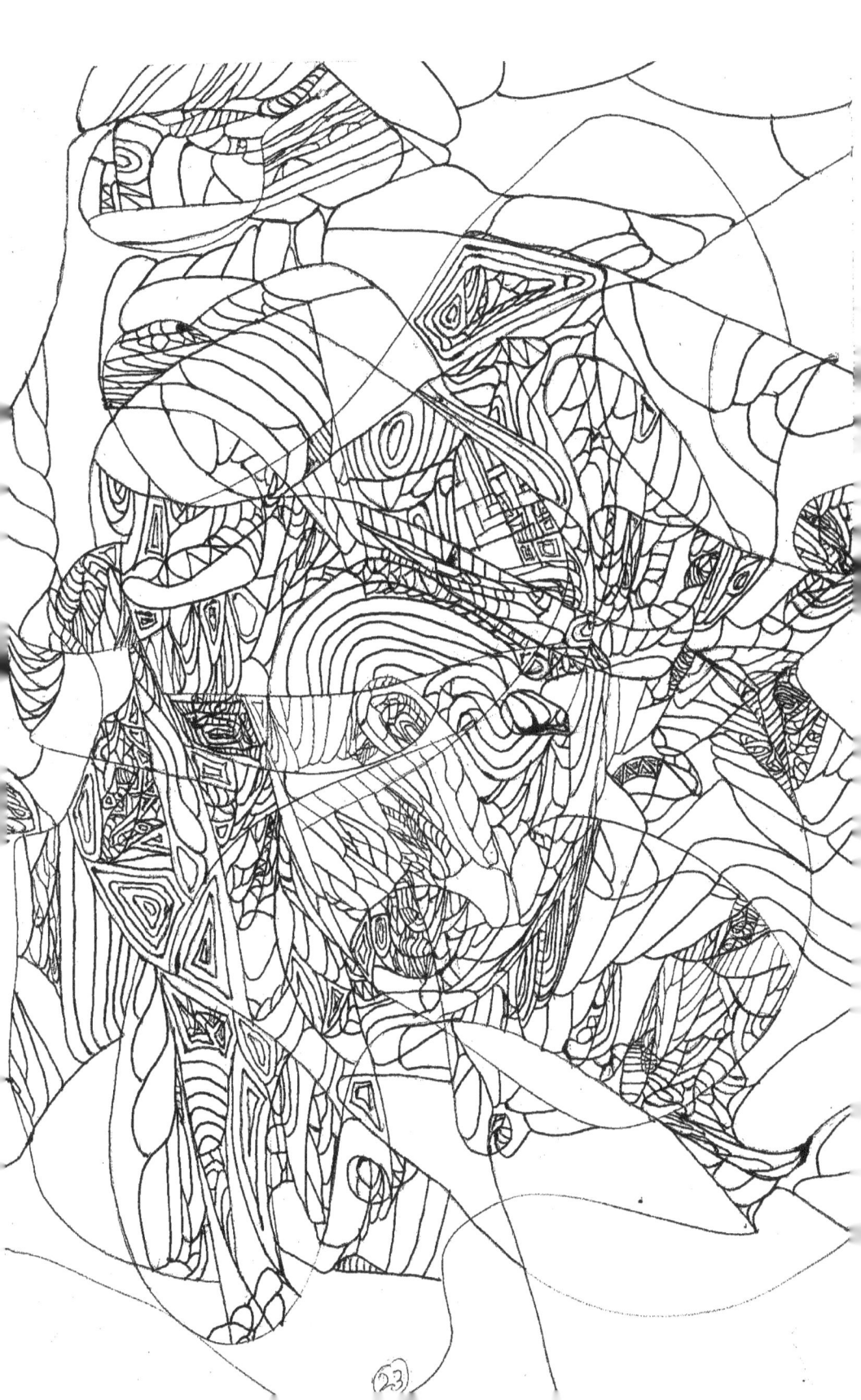

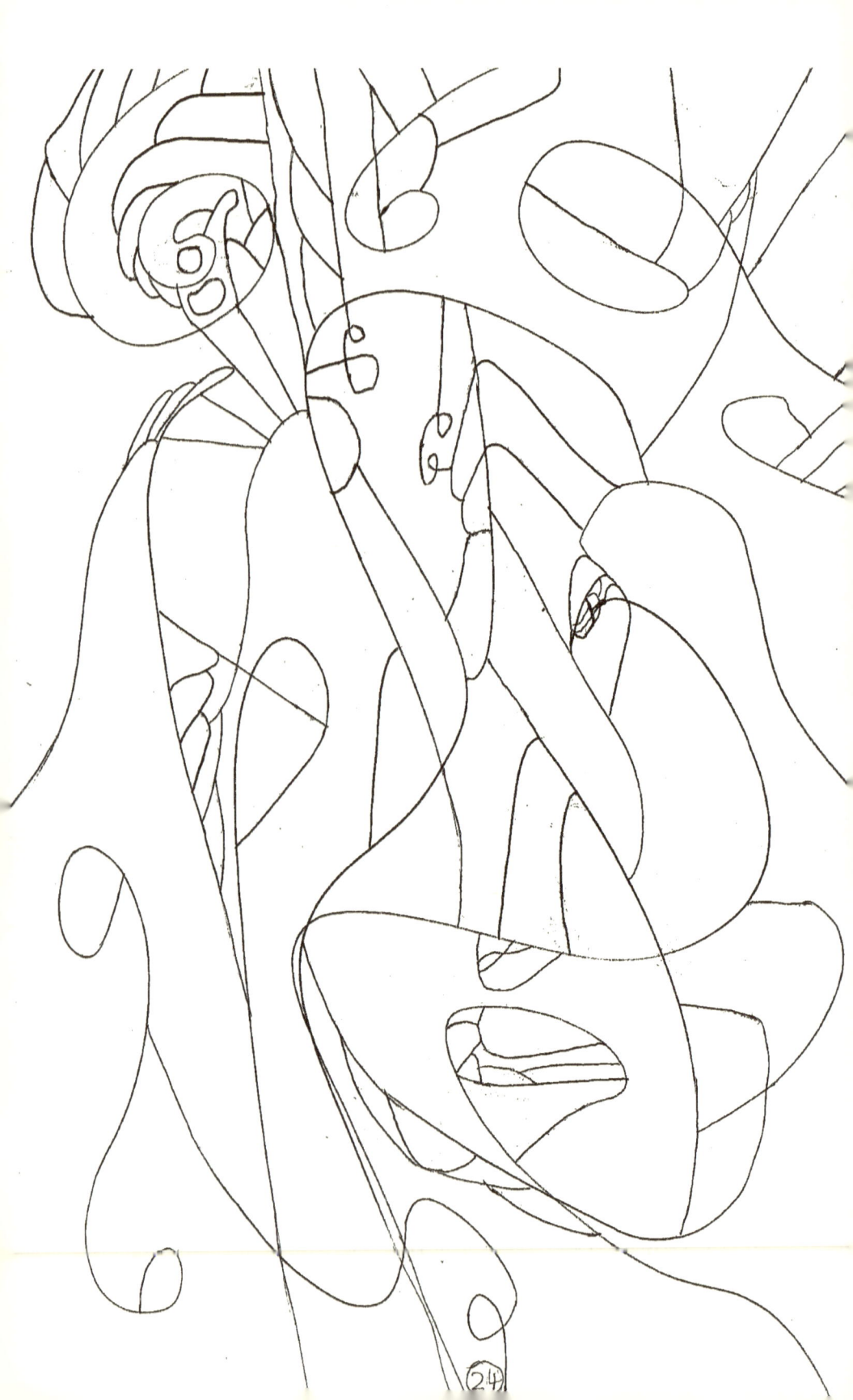

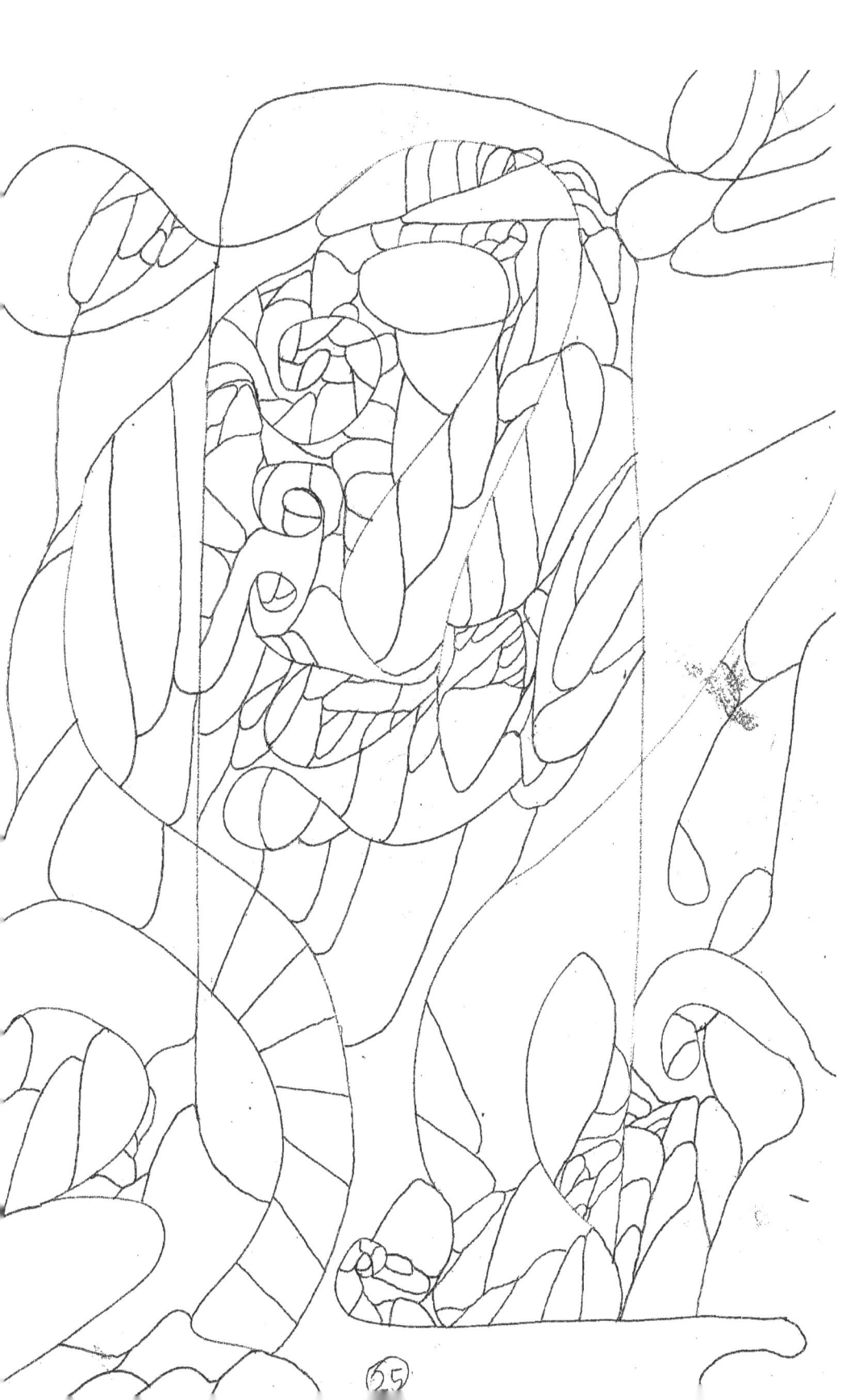

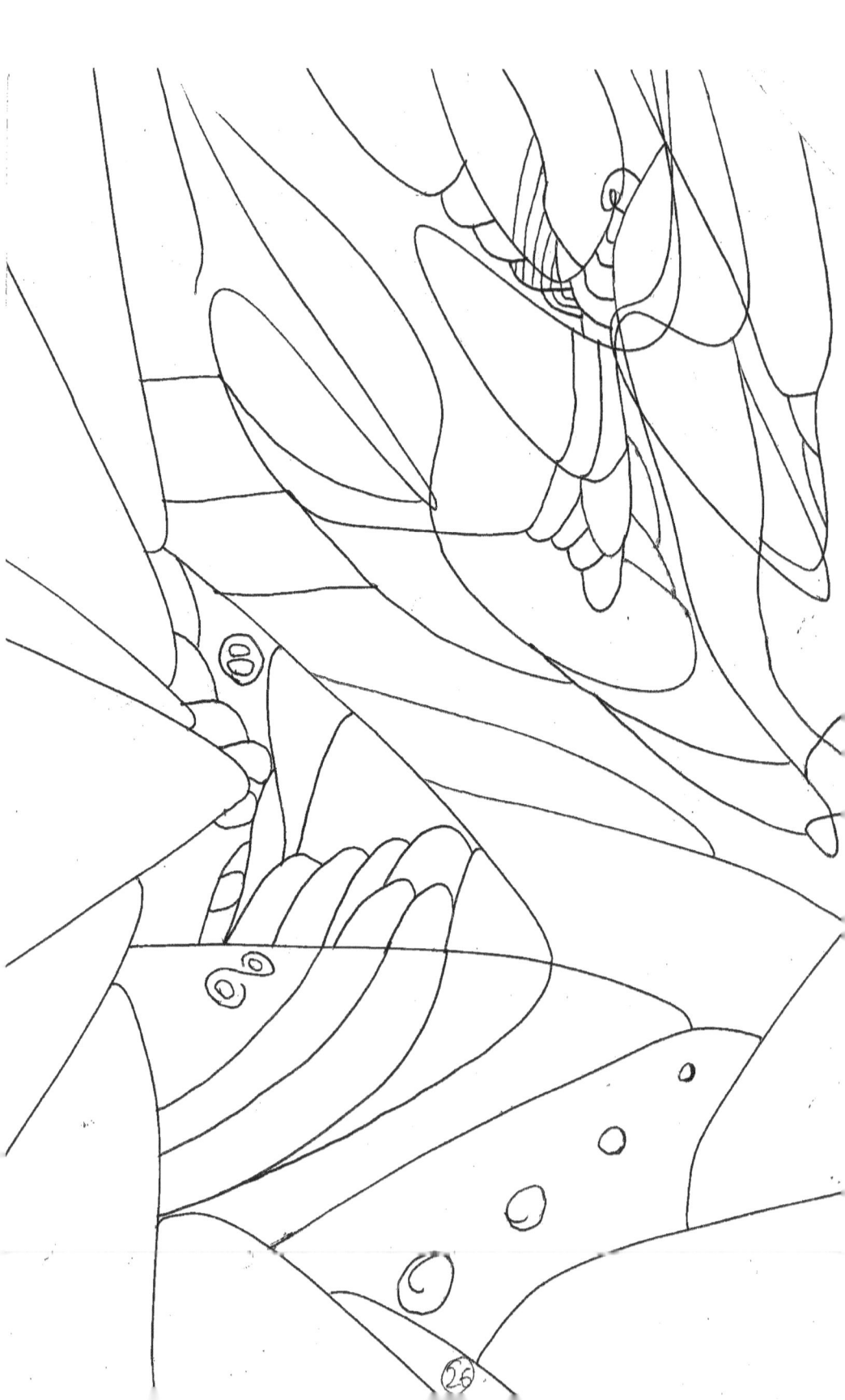

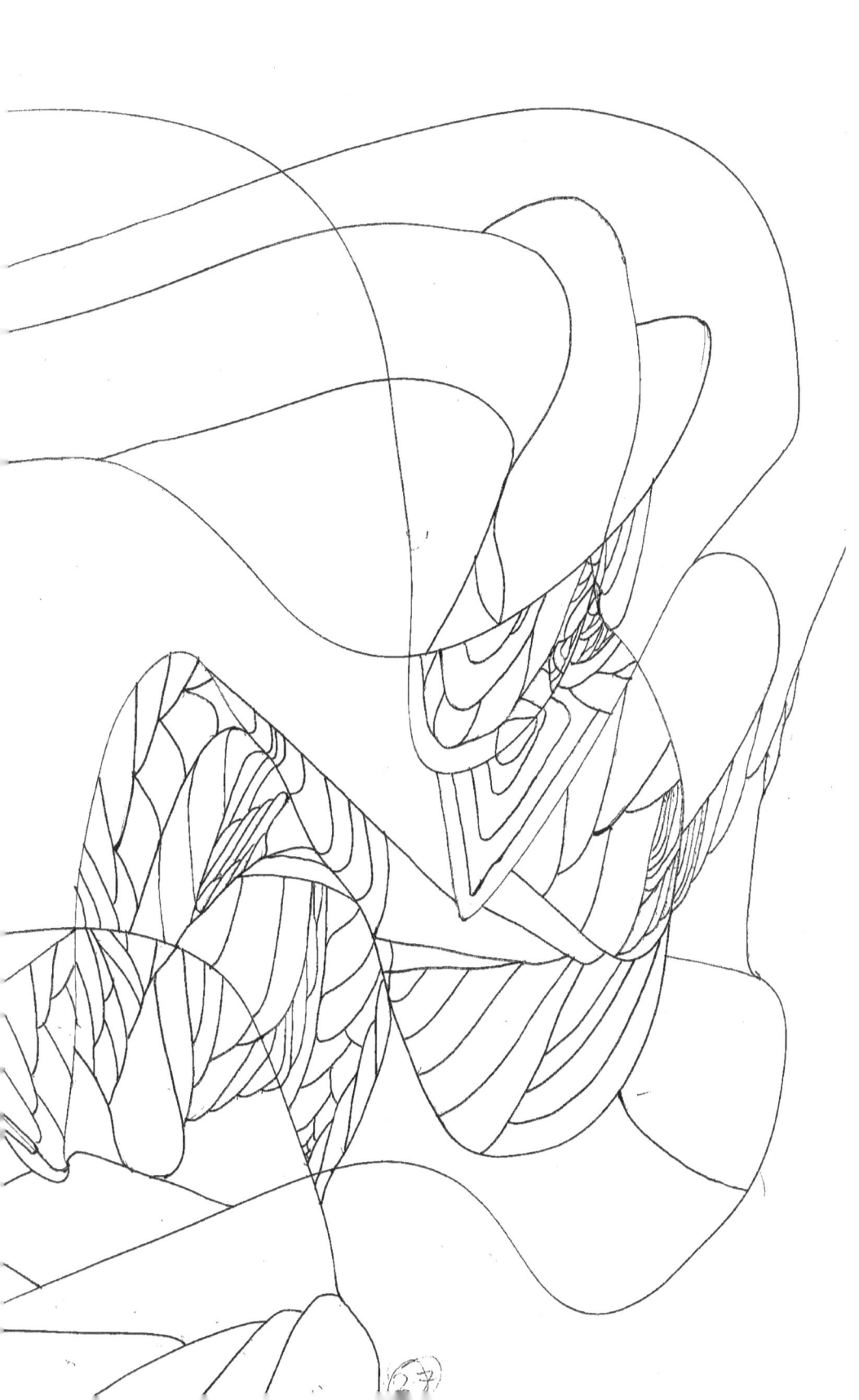

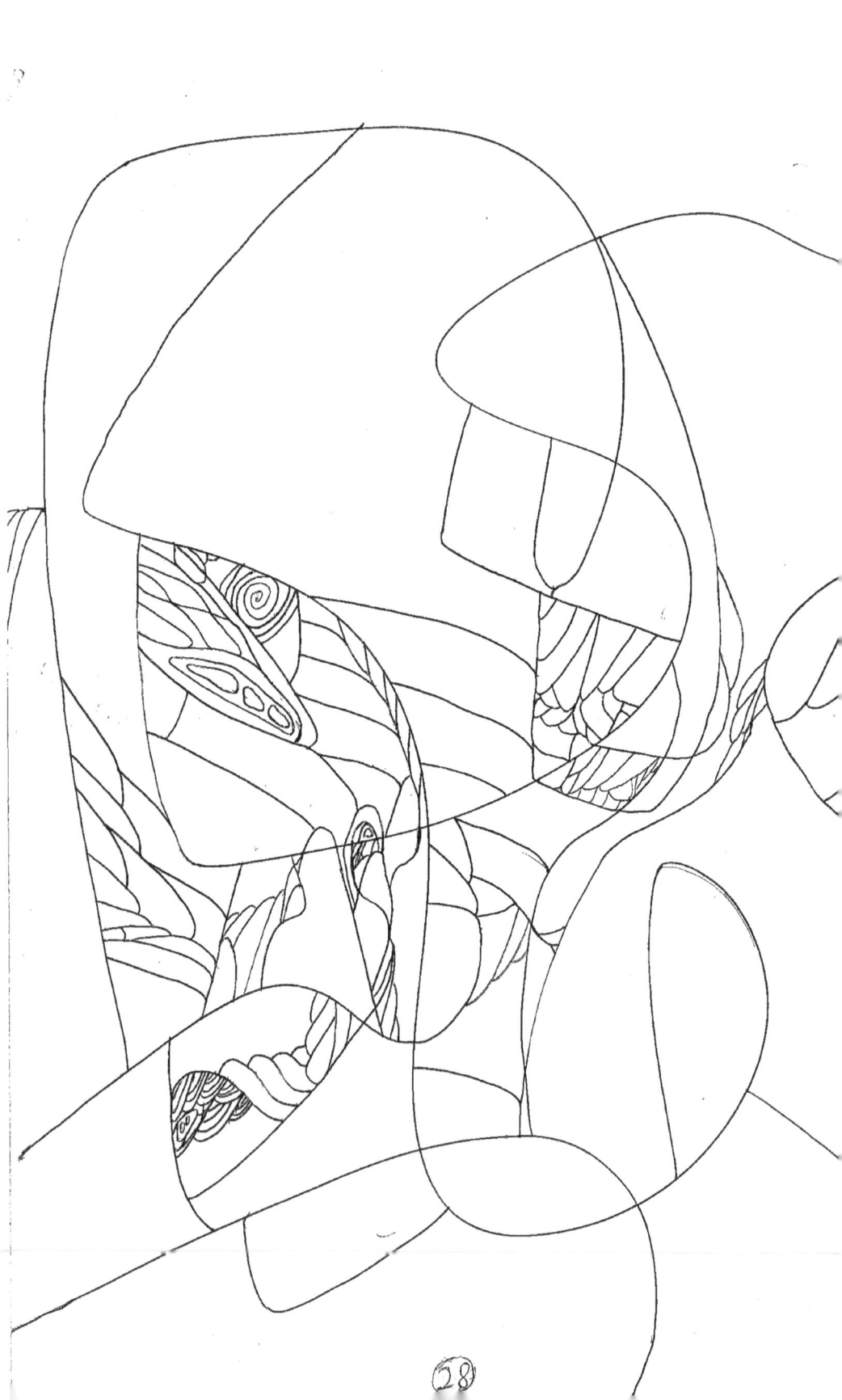

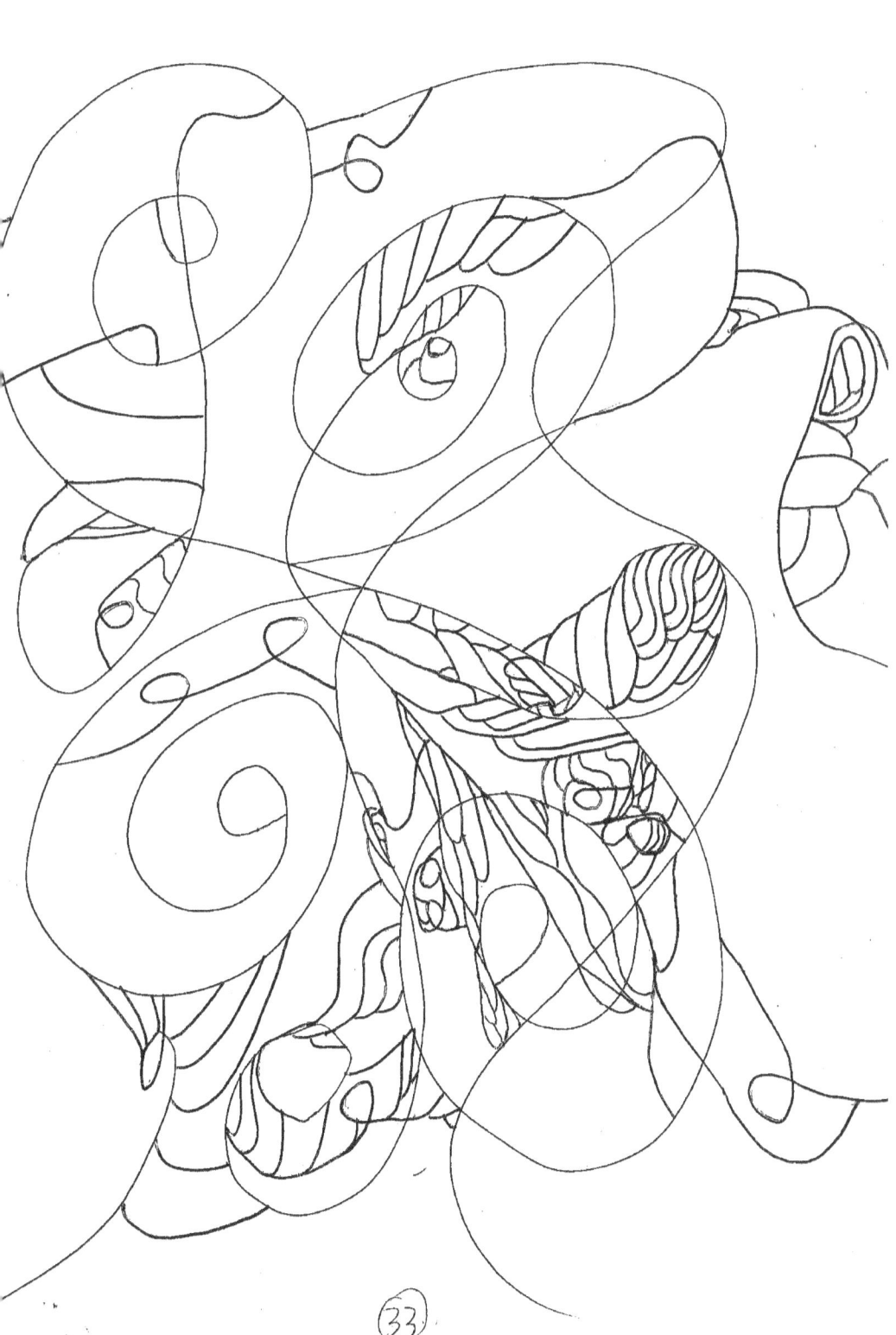

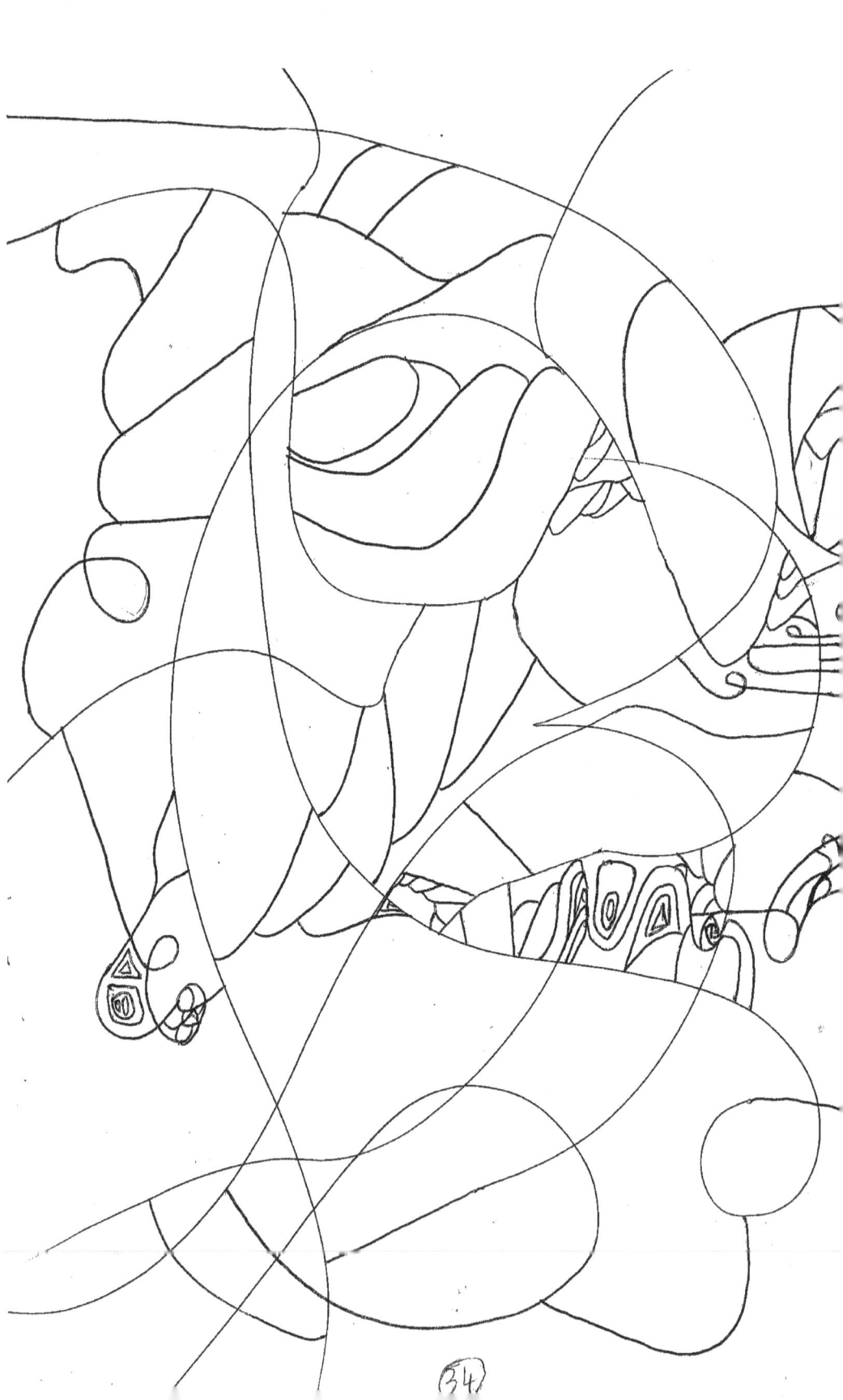

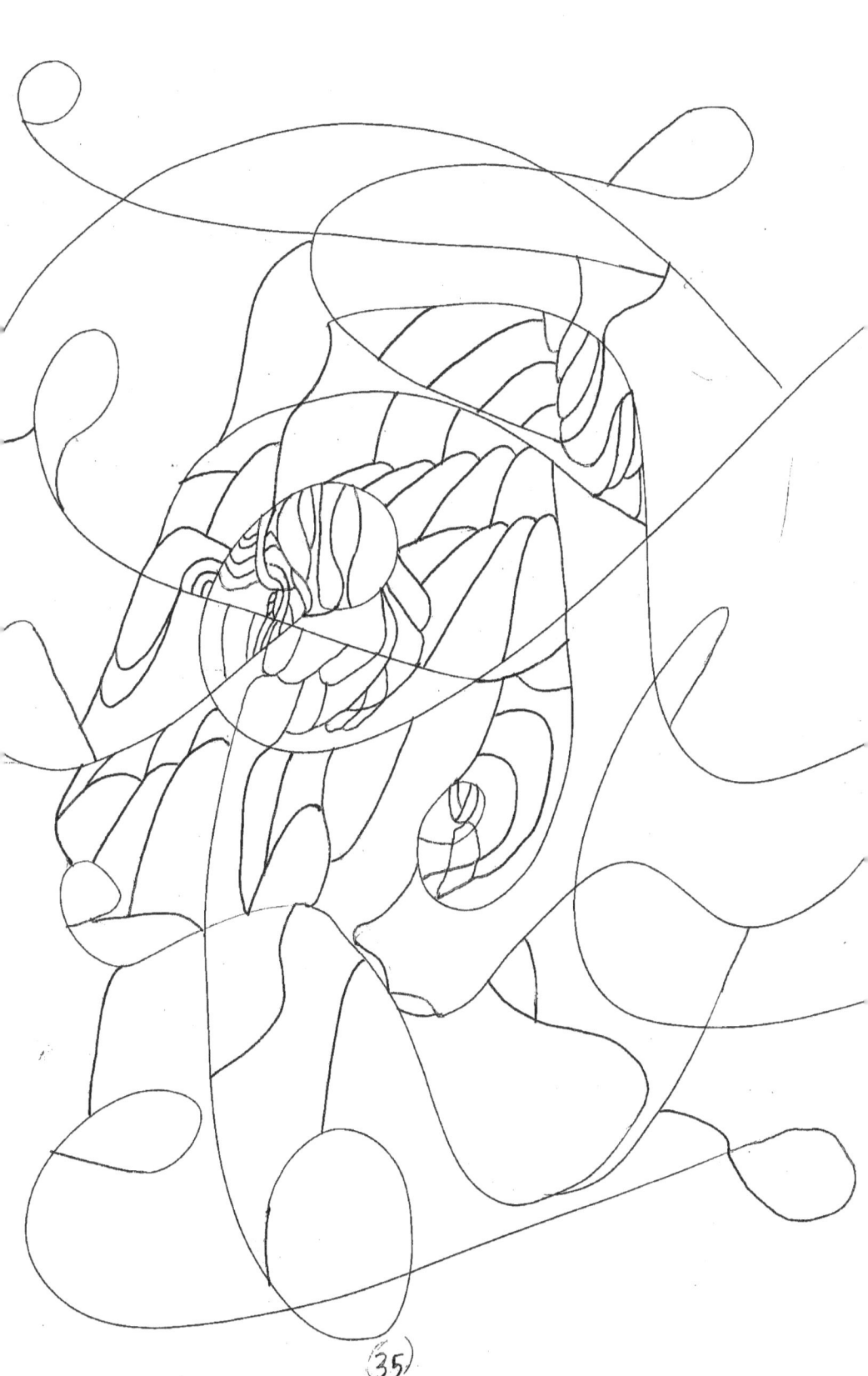

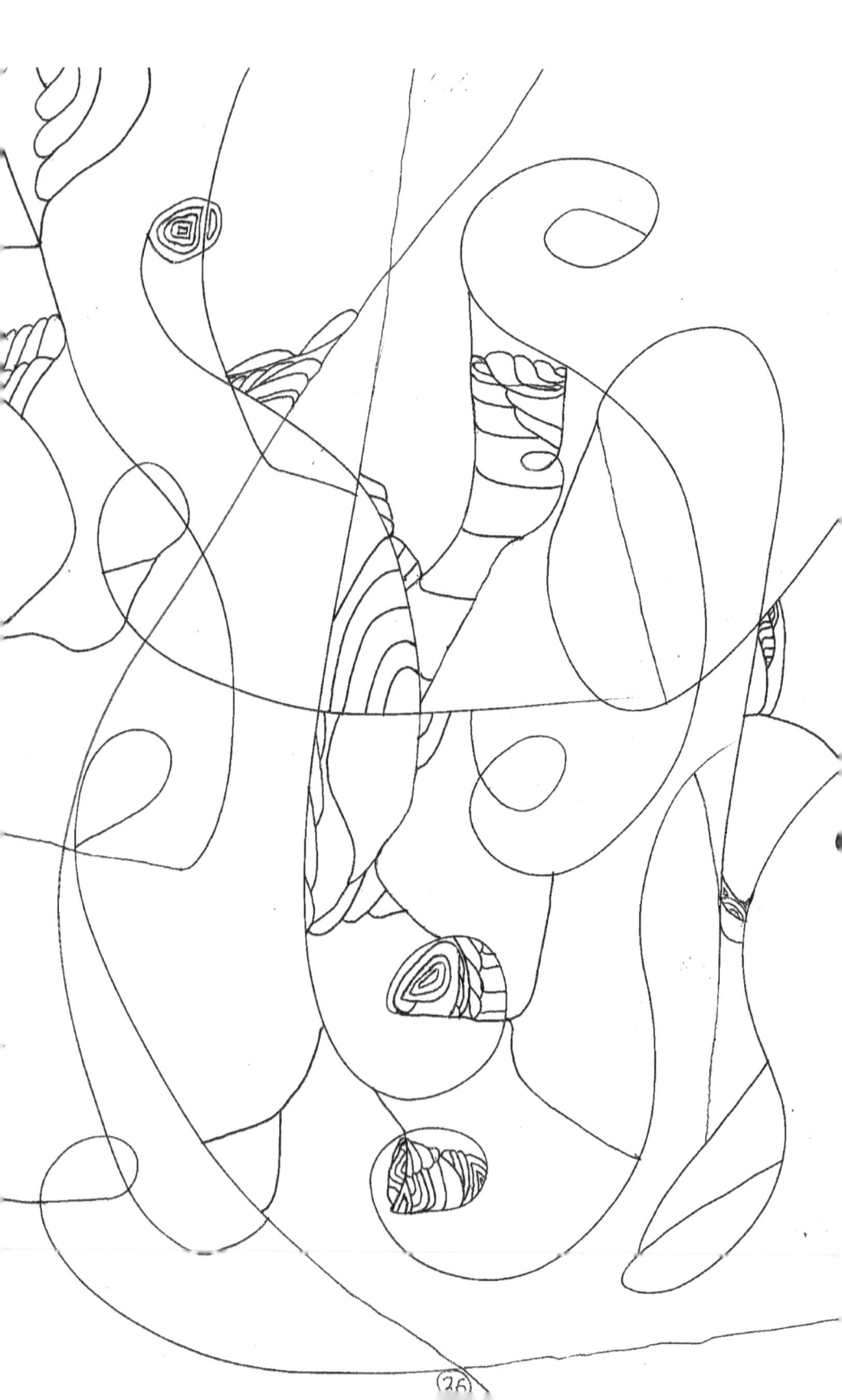

www.ingramcontent.com/pod-product-compliance
Lightning Source LLC
Chambersburg PA
CBHW021850170526
45157CB00006B/2385